You're My Woman Because...

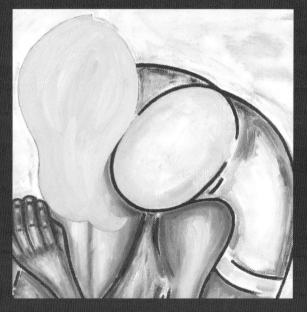

Patrick J. Murphy

RED ROCK PRESS, NEW YORK

ISBN 978-1-9331-7617-8
L.O.C. 2006940611

Published by Red Rock Press
New York, New York
U.S.A.

www.RedRockPress.com

CONTACT:

info@RedRockPress.com

LAYOUT & DESIGN:

Tor Anderson, Telluride, Colorado
tordesigns@gmail.com

PRINTED IN SINGAPORE

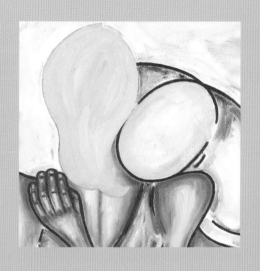

You're My Woman Because...

. . . you look stunning
in my shirt.

. . . you share your dessert with me.

...with you on my side
I can't lose.

...we communicate
so much without
saying a word.

. . . you save the slow dance for me.

...you're pure magic.

...you bring sunshine into my life.

...you understand
when I have
to work late.

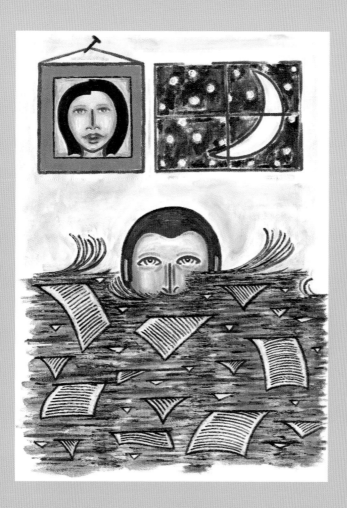

...you bring the
feminine touch
into my life.

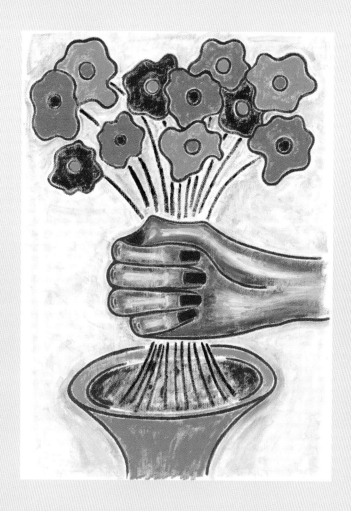

...you are the
missing piece
I was searching for.

...you know the
right thing to say.

...you understand
mowing the lawn
takes a long time.

...new shoes put you in a trance.

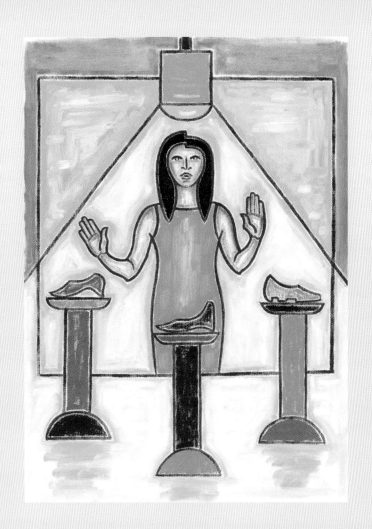

...you know how
to be happy.

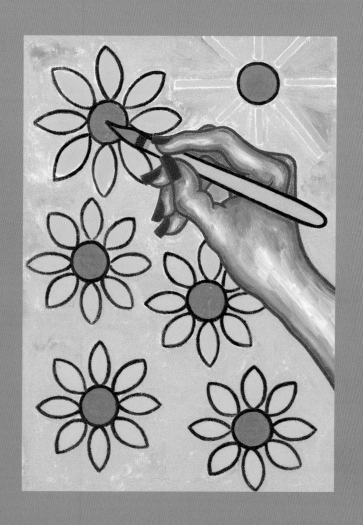

...we connect
so beautifully.

...you took a
chance on me.

...you keep the fridge stocked with essentials.

...I'm your hero
when you need one.

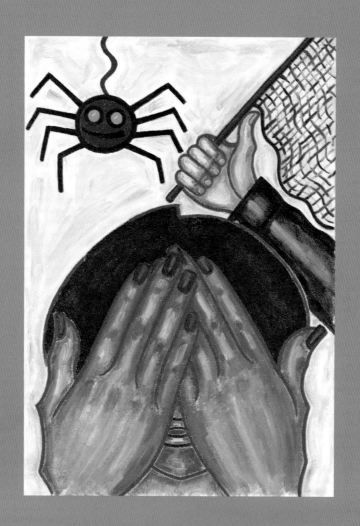

...you look so beautiful
while you're sleeping.

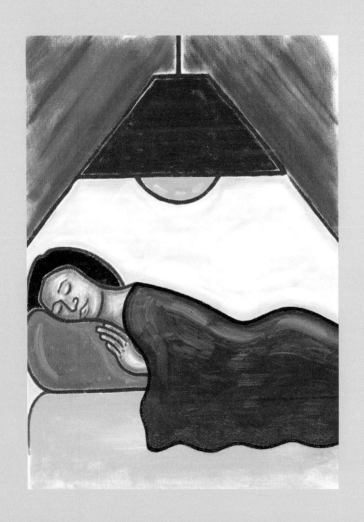

...you're so hot.

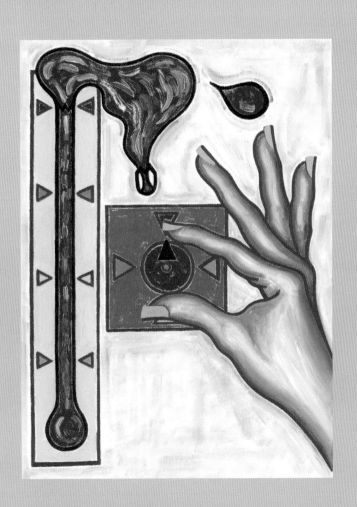

...you put on your rose-tinted glasses every time you look at me.

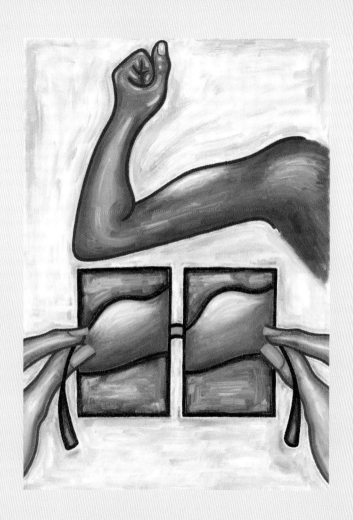

...we got chemistry.

...you take care of
my fragile ego.

. . . you make life
seem so easy.

...your honey
is simply irresistible.

...you're not jealous
of the other woman
in my life.

...you make me
feel like this.

...you opened my heart
and made it fly.

...I can share my
difficult moments
with you.

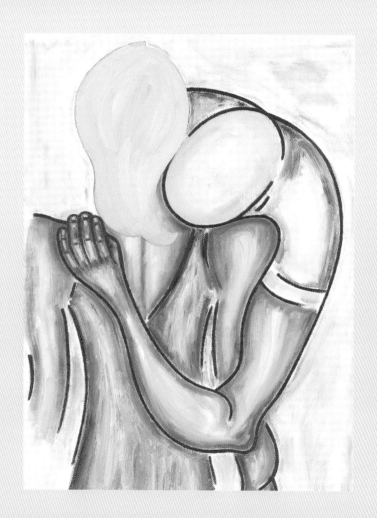

...you light up
my universe.

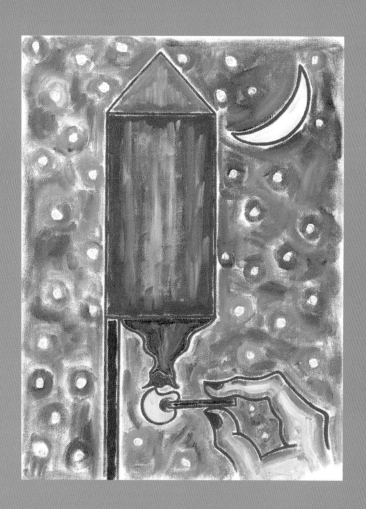

...you're there for me
whatever the weather.

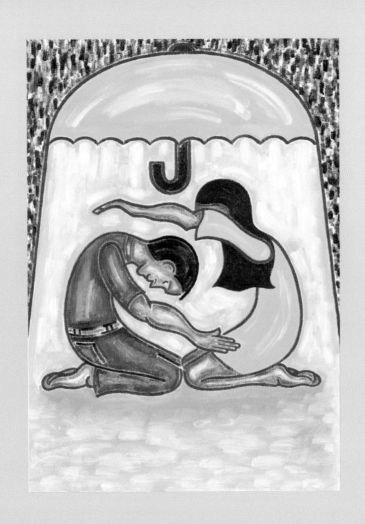

...you cheer me up.

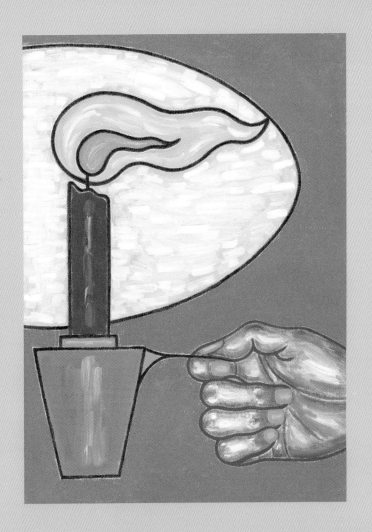

...you look great
whatever you wear.

...you stole the key
to my heart.

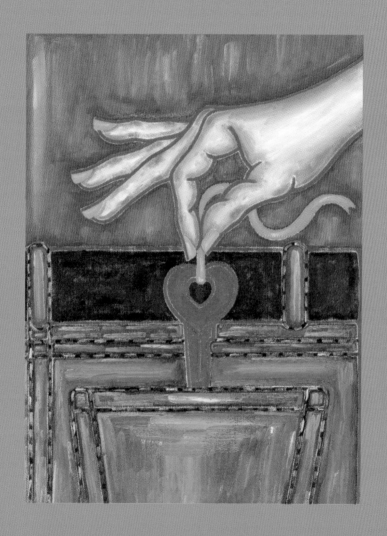